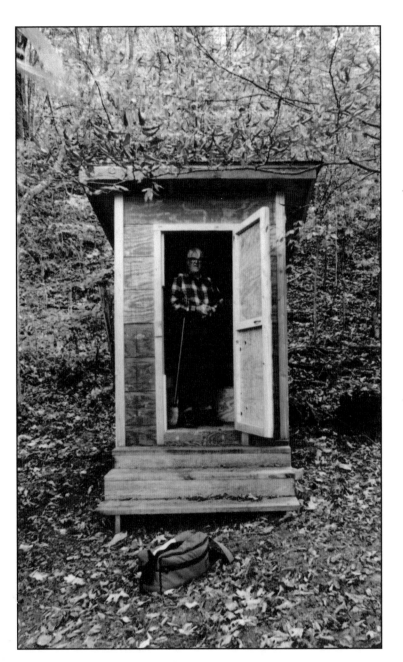

Outhouses I Have Known

Photos by
Warren E. Brunner

ISBN 9781481237819

Published in the United States of America

Peachbloom Press
patjbrunner@gmail.com

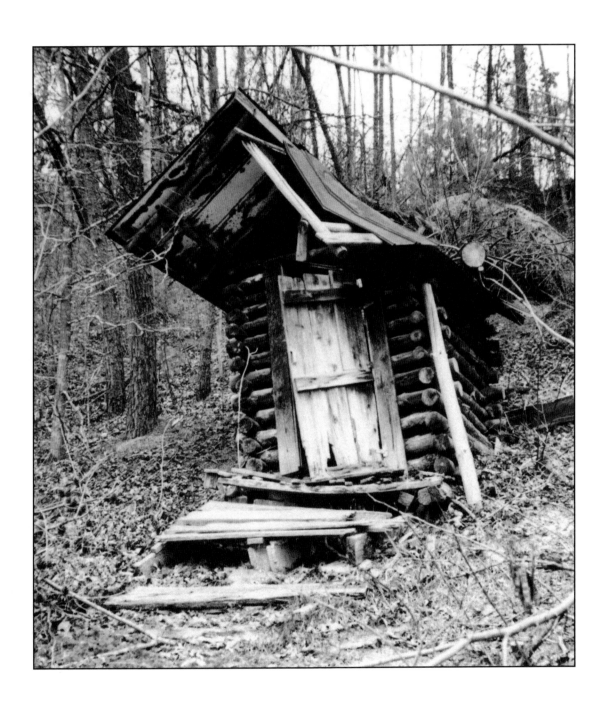

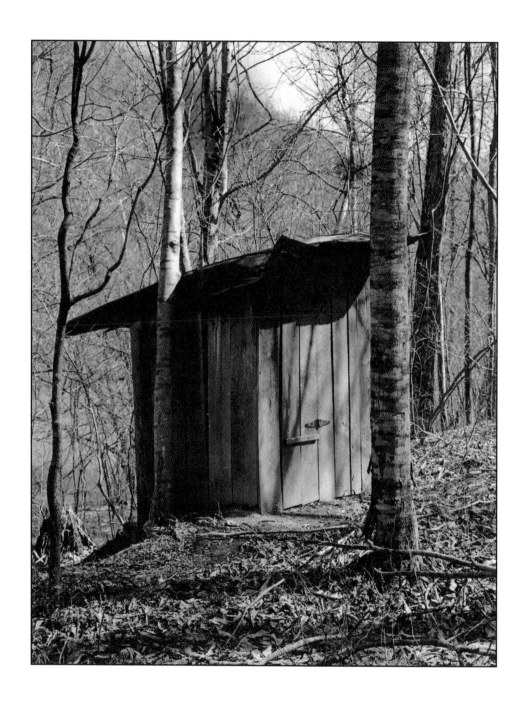

The Passing of the Outhouse

When memory
keeps me company
and moves to smile or tears,
A weather-beaten object
looms throughout
the mist of years.

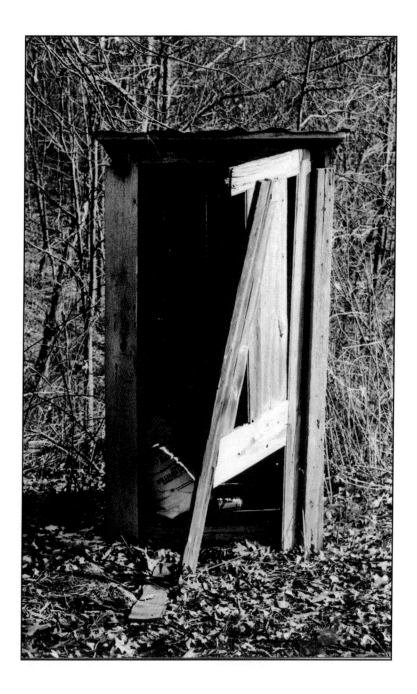

Behind the house and barn it stood,
A half a mile or more,
And hurrying feet a path had made,
straight for its swinging door.

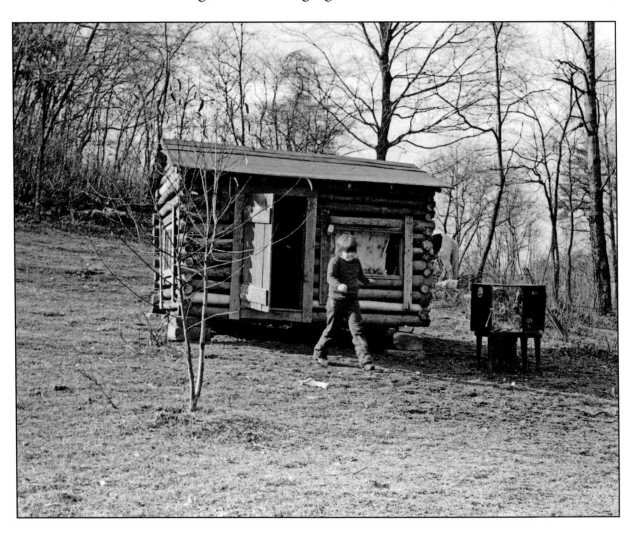

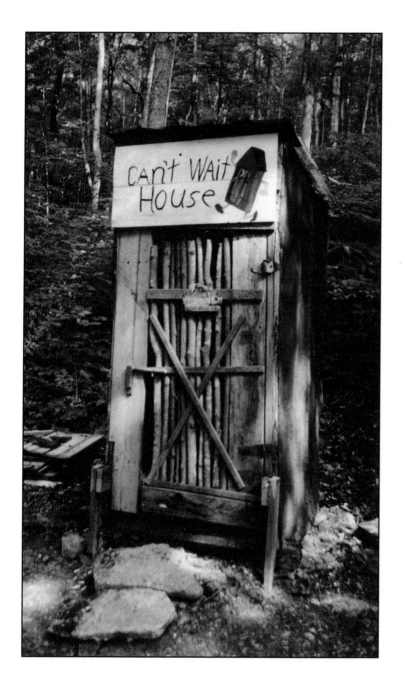

Its architecture was a type of
simple classic art,
But in the tragedy of life
it played a leading part.

And oft the passing
traveler drove slow
and heaved a sigh,
To see the modest hired girl
slip out with glances shy.

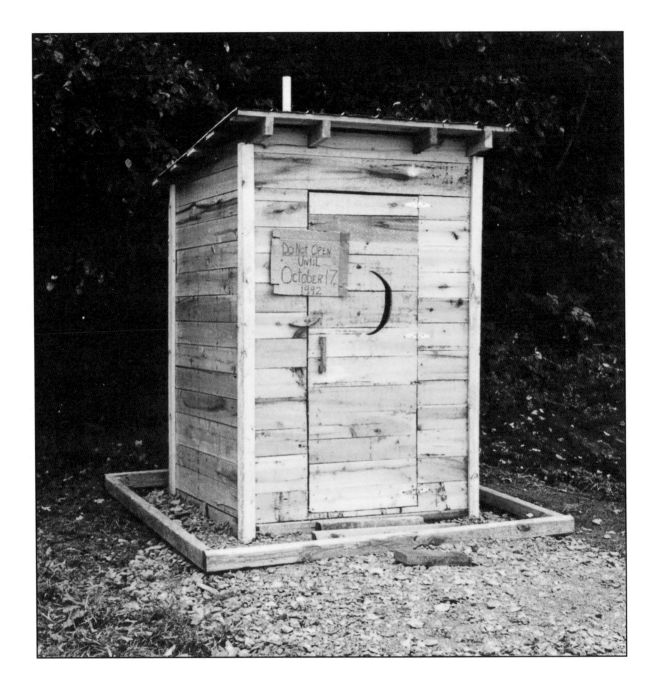

We had our posey garden
That the women loved so well.
I loved it, too, but better still
I loved the stronger smell.

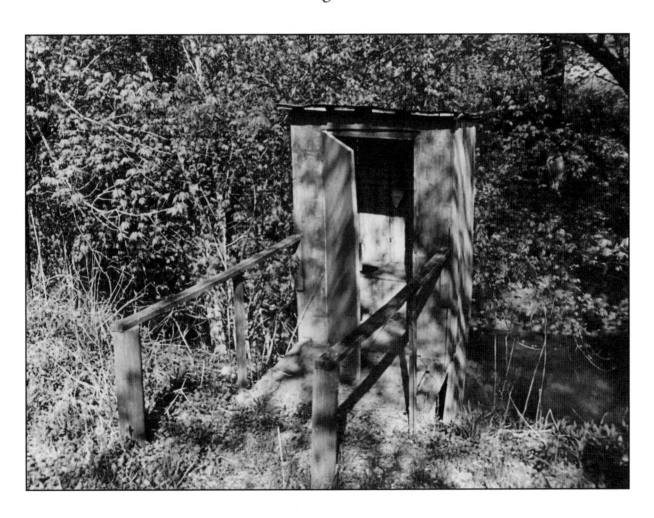

That filled the
evening breezes
So full of homely cheer
And told the
night-o'ertaken tramp
That human life was near.

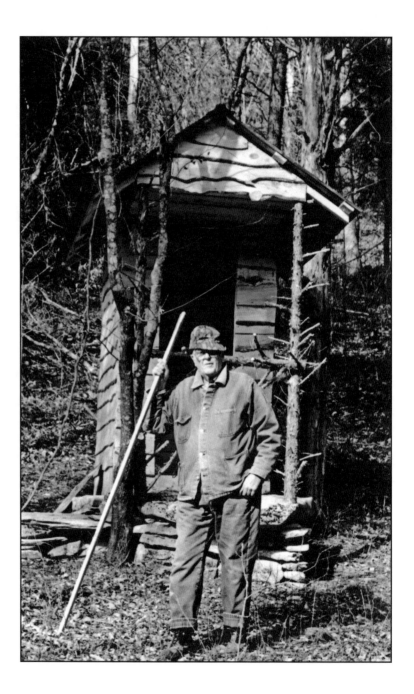

On lazy August afternoons,
It made a little bower.
Delightful, where my grandsire sat
And whiled away an hour.

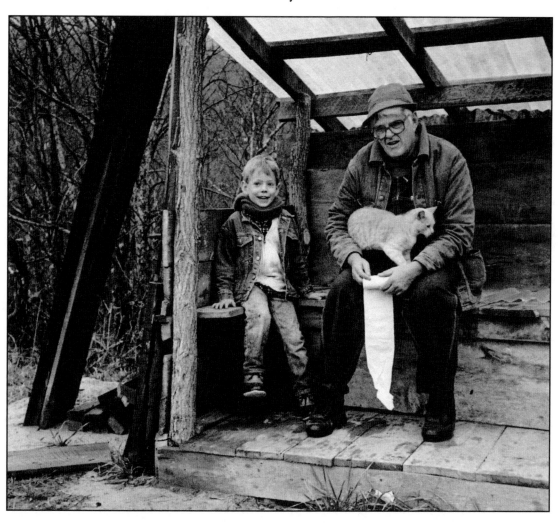

For there the summer mornings
Its very cares entwined.
And berry bushes reddened
In the teeming soil behind.

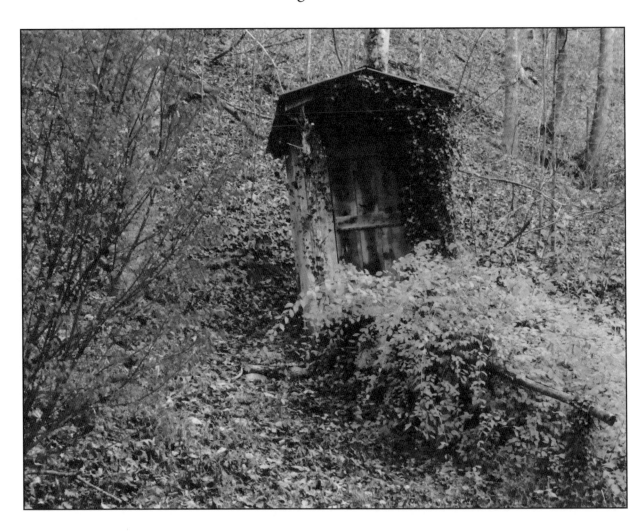

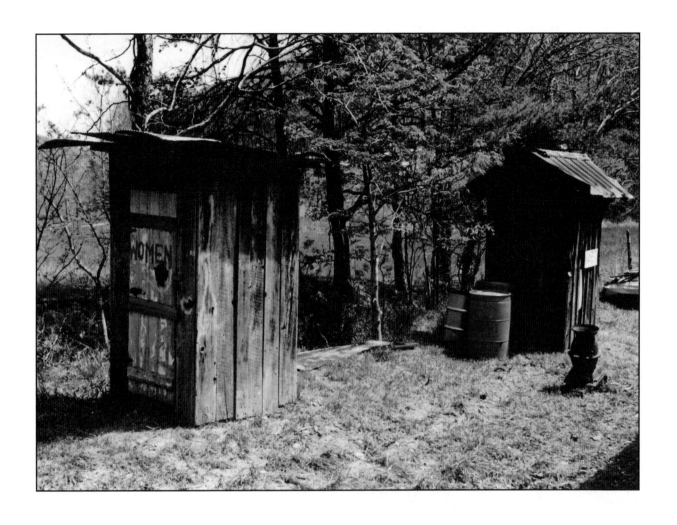

All day fat spiders spun their webs
To catch the buzzing flies
That flitted to and from the house
Where Ma was baking pies.

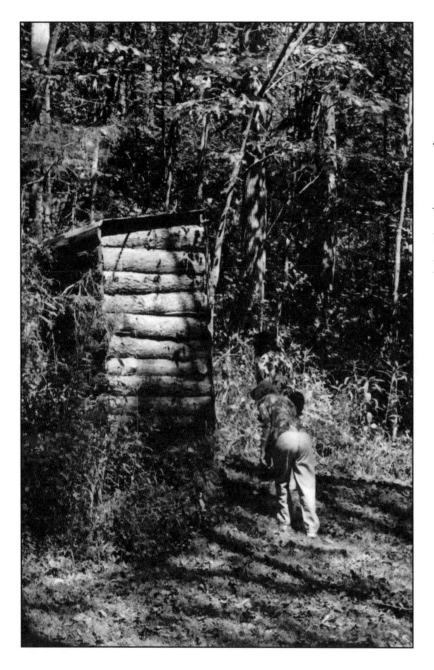

And once a swarm of
hornets bold
 Had built a palace there,
And stung my
unsuspecting aunt –
I must not tell you where.

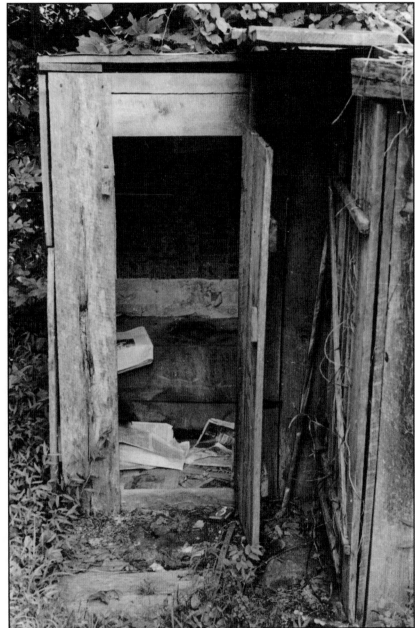

Then father took a
flaming pole
--That was a happy day--
He nearly burned the
building up
But the hornets left to stay.

When summer bloom began to fade
And winter to carouse,
We banked the little building
With a heap of hemlock boughs.

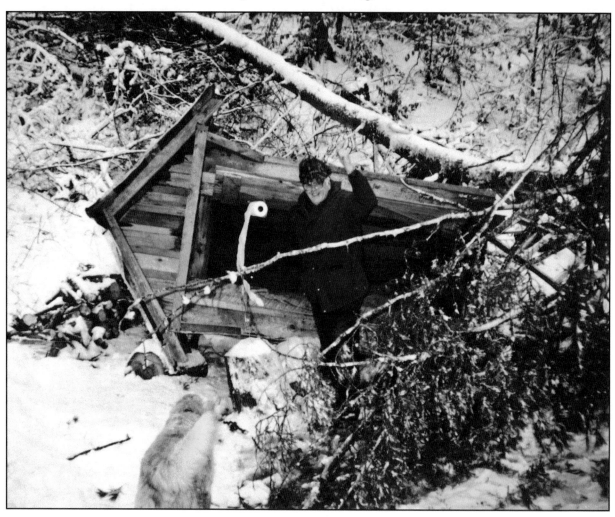

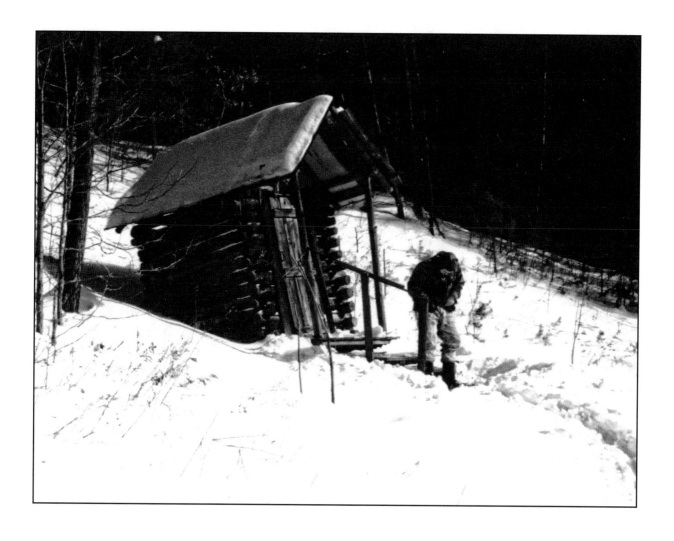

But when the crust was on the snow
And the sullen skies were gray,
In sooth the building was no place
Where one could wish to stay.

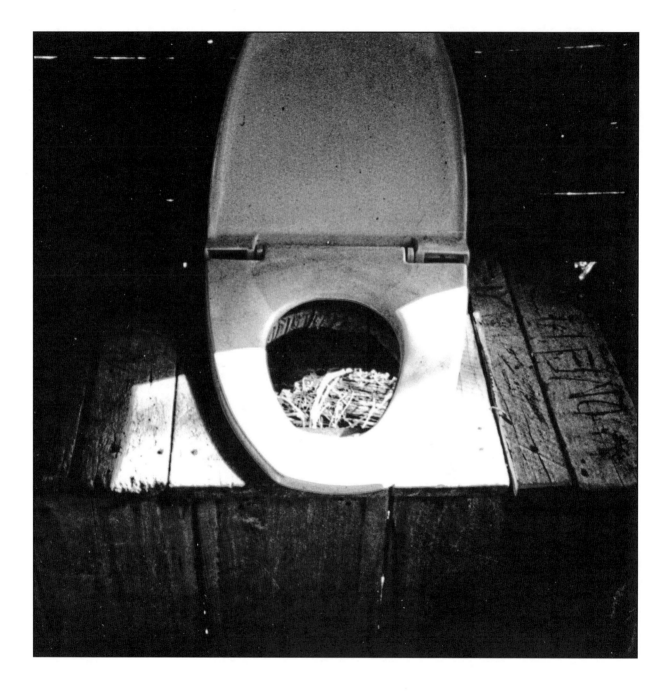

We did our duties
promptly;
There one purpose
swayed the mind.
We tarried not,
nor lingered long
On what we left behind.

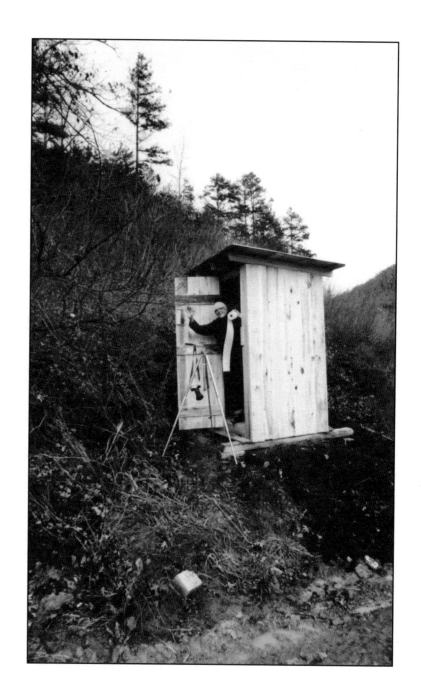

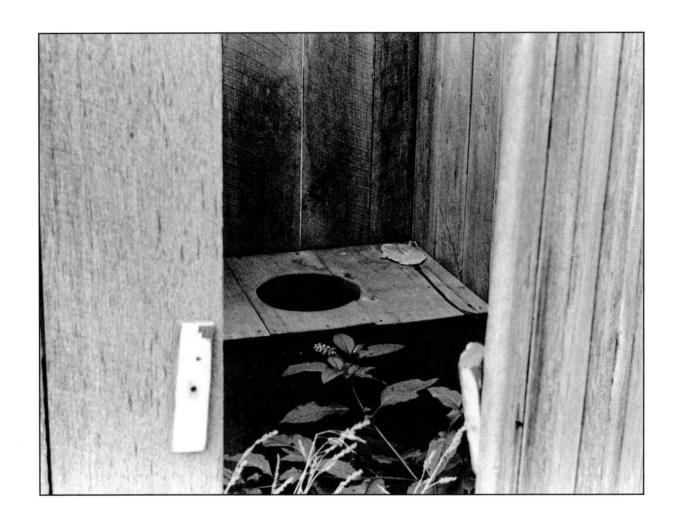

The torture of that icy seat
 Would made a Spartan sob,
For needs must scrape the gooseflesh
With a lacerating cob.

That from a frost-encrusted nail
Was suspended by a string –
My father was a frugal man
And wasted not a thing.

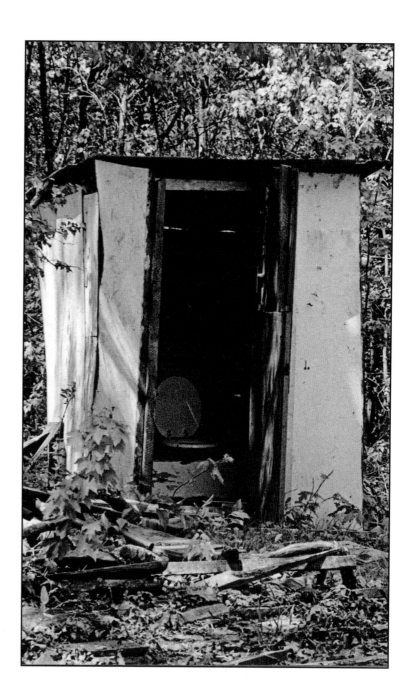

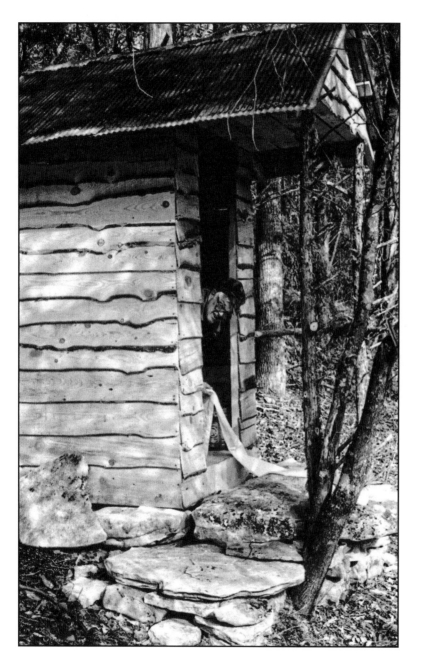

When Grandpa had
to "go out back"
And make his morning call,
We'd bundle up
the dear old man
With a muffler and
a shawl.

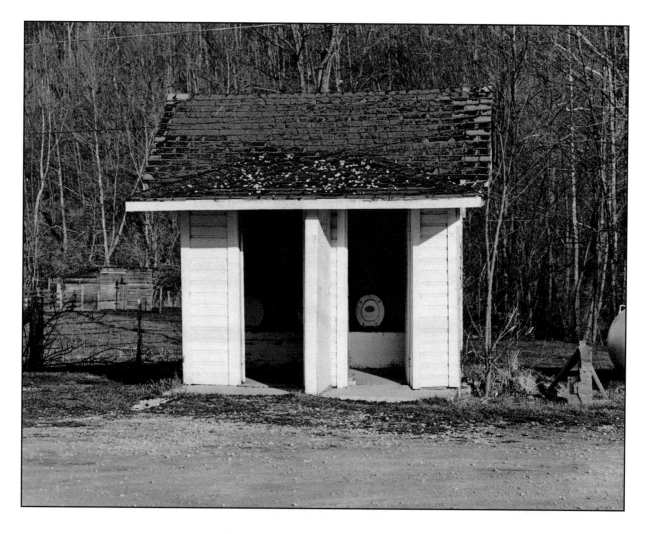

I knew the hole on which he sat
'Twas padded all around,
And once I dared to sit there;
'Twas all too wide, I found.

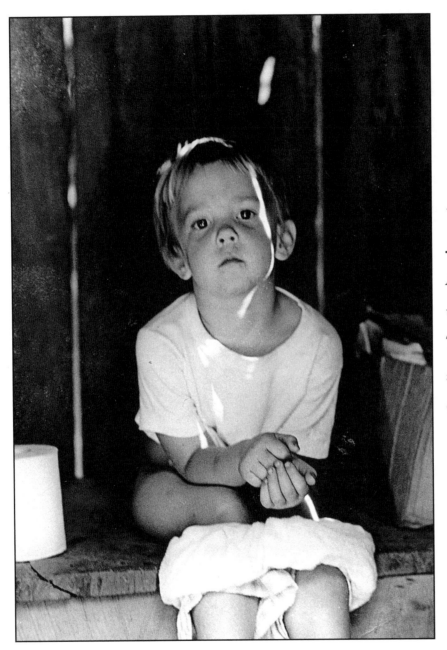

My loins were
all too little
And I jack-knifed
there to stay;
They had to come
and pry me out
Or I'd have passed away.

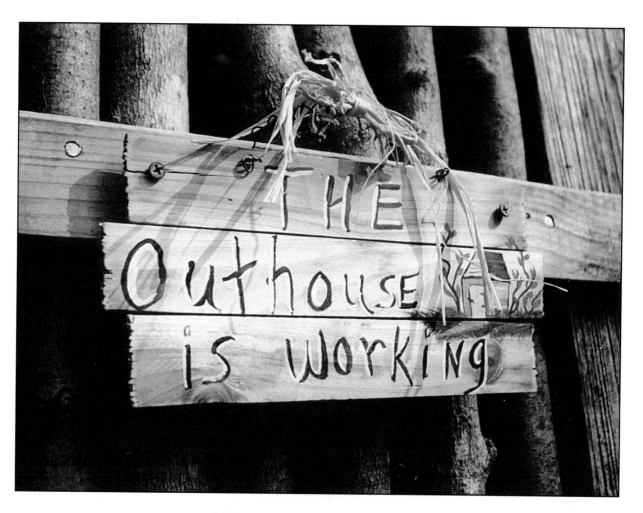

Then father said ambition
Was a thing small boys should shun,
And I must use the children's hole
Till childhood days were done.

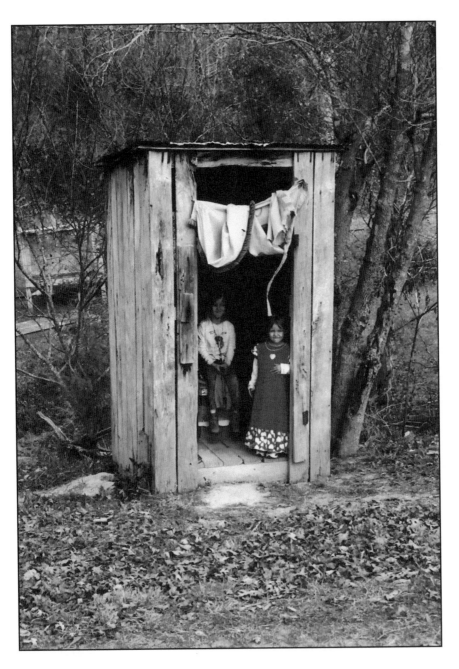

And still I
marvel at
the craft
That cut those holes
so true;
The baby hole and
the slender hole
That fitted
Sister Sue.

That dear old country
landmark!
I've tramped around a bit,
And in the lap of luxury
My lot has been to sit.

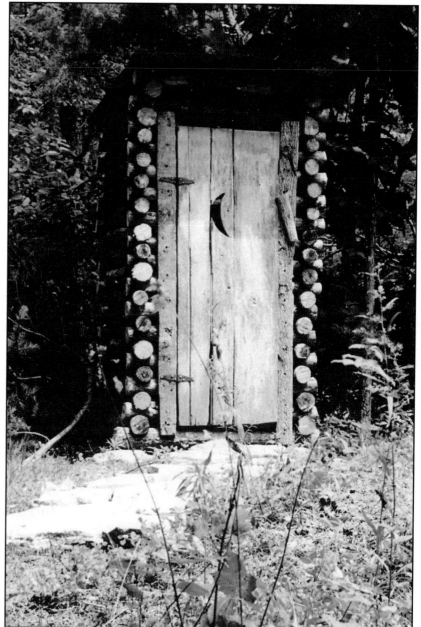

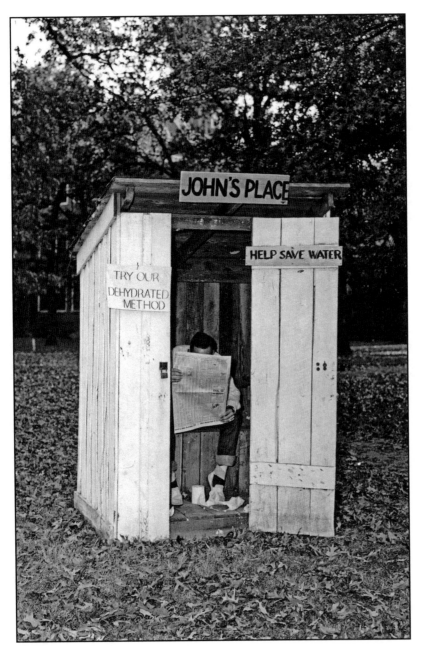

But ere I die I'll eat the fruit
Of trees I robbed of yore,
Then seek the shanty
where my name
Is carved upon the door.

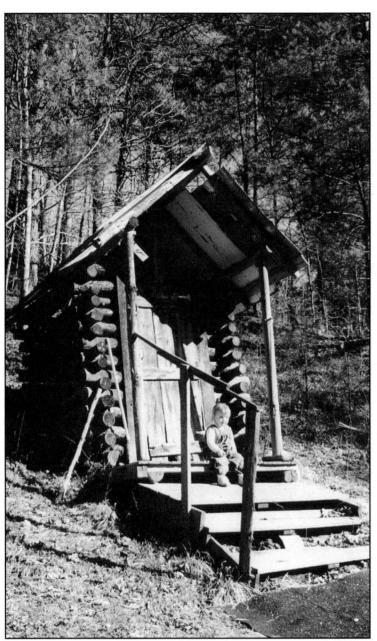

I ween the old familiar smell
Will soothe my jaded soul,
I'm now a man, but none the less
I'll try the children's hole.

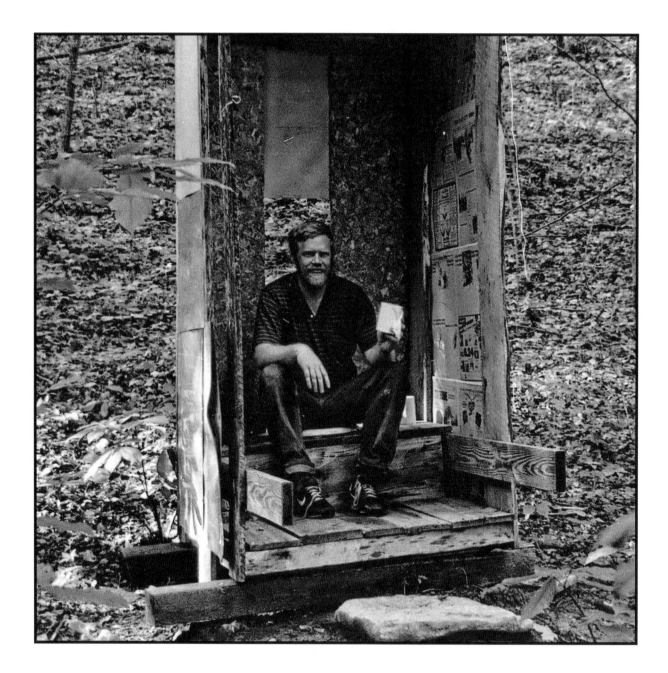

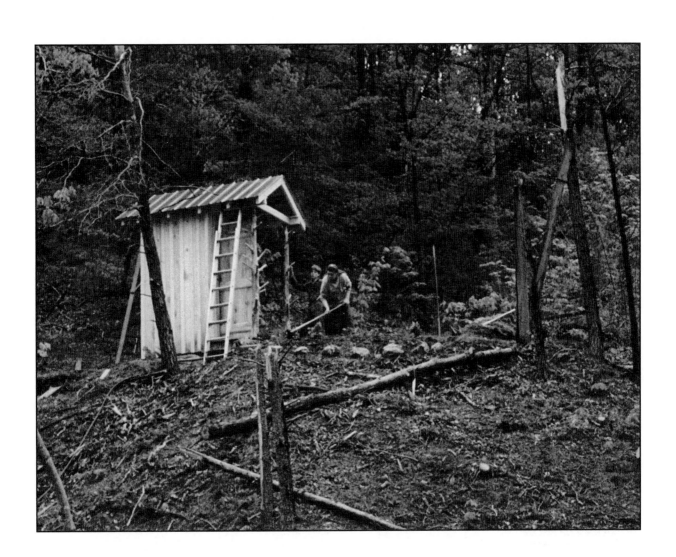

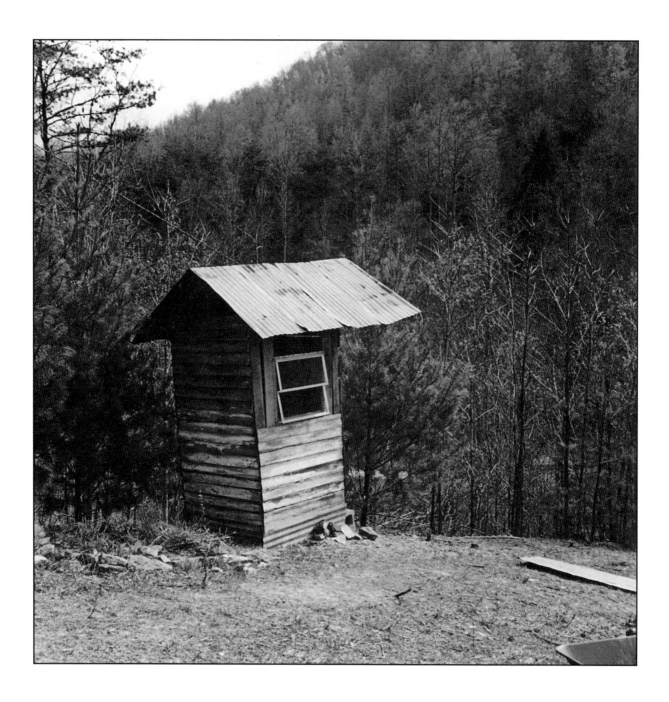

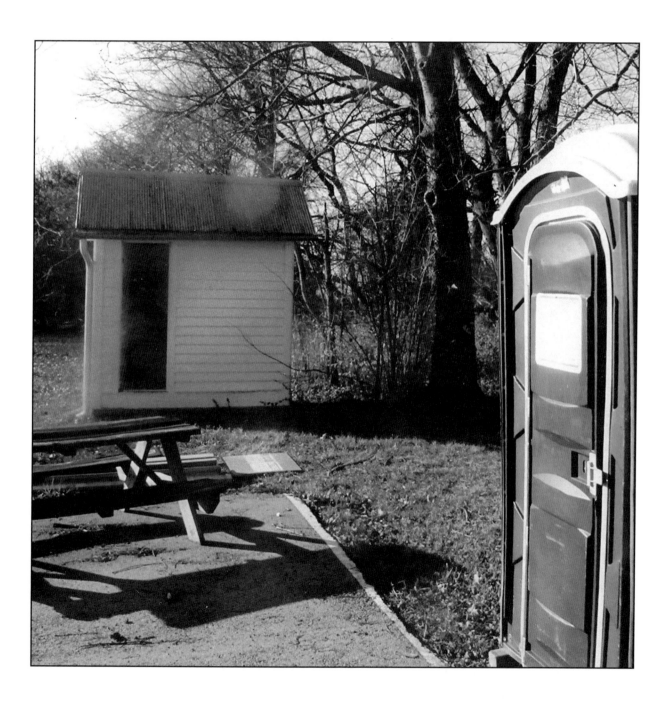

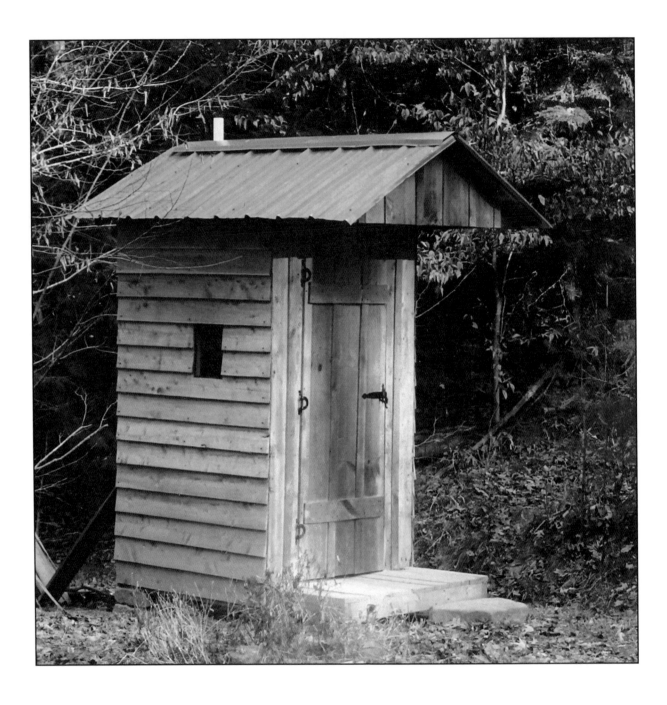

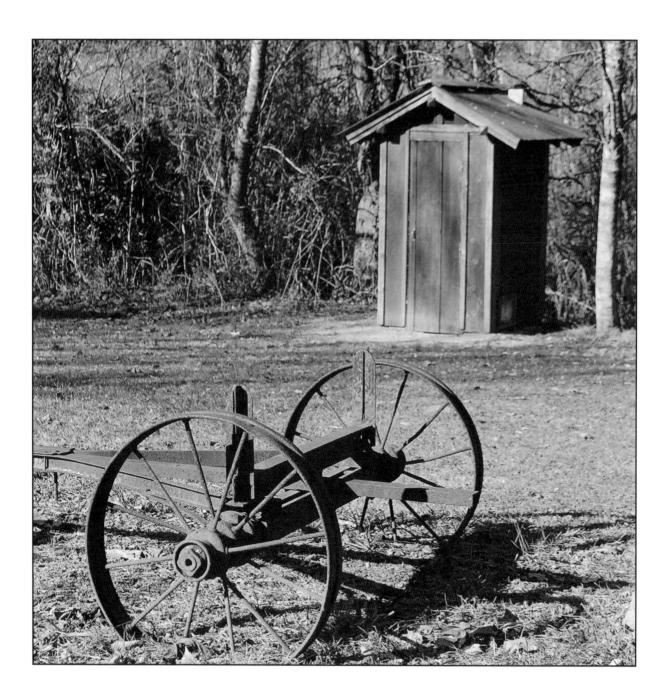

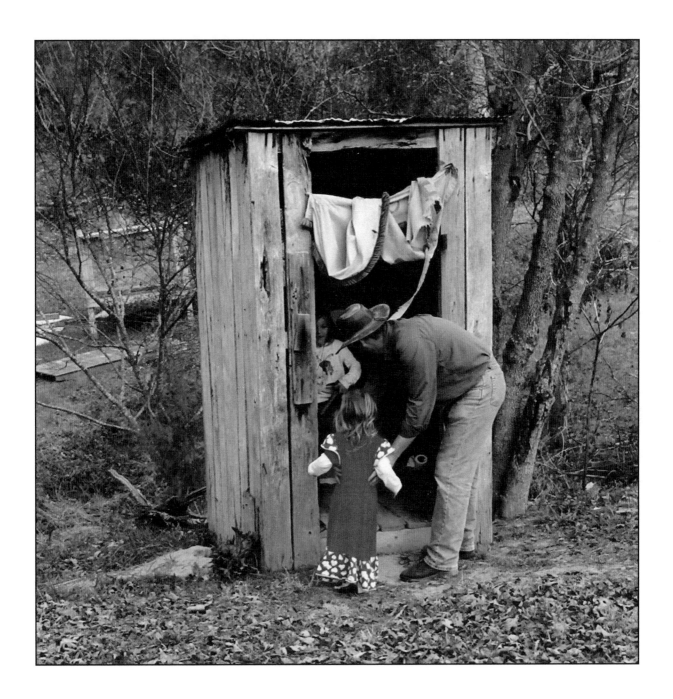

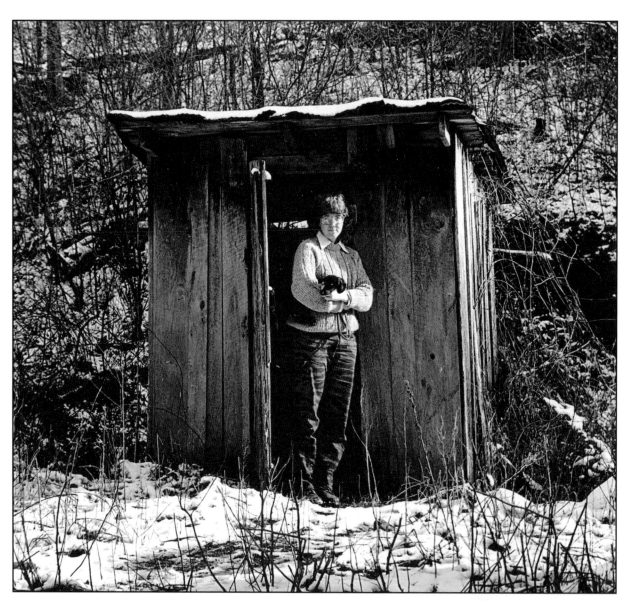

Layout by
Gwen Brunner Hensley

"The Passing of the Outhouse" is attributed to James Whitcomb Riley but according to his family it was never included in his published works. It has also been attributed to Charles T. Rankin. No active copyright found.

23524876R00022

Made in the USA
Charleston, SC
25 October 2013